me

the
all

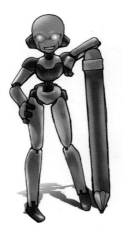

Yishan Li

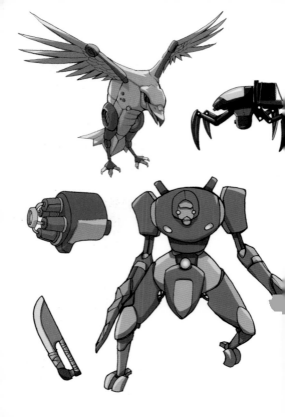

mecha manga

the pocket reference to drawing all manga robots and machines

Yishan Li

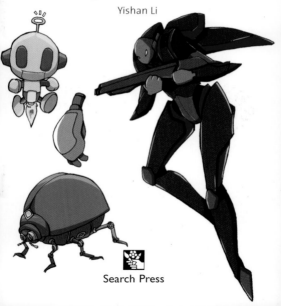

Search Press

First published in Great Britain 2010 by
Search Press Limited
Wellwood, North Farm Road,
Tunbridge Wells, Kent TN2 3DR

Created and conceived by
Axis Publishing Limited
8c Accommodation Road
London NW11 8ED
www.axispublishing.co.uk

Creative Director: Siân Keogh
Editor: Anna Southgate
Art Director: Sean Keogh
Production Manager: Jo Ryan

ISBN: 978-1-84448-521-5

contents

Introduction 6

equipment 10

form and structure 20

mecha components 32

weapon design 48

materials and textures 58

mecha world 66

■ basic mecha 68

■ military mecha 82

■ animal mecha 126

■ industrial mecha 144

■ service mecha 166

■ chibi mecha 180

Index 190

Introduction

Originating in Japan, manga art has become popular across the globe. Taking its name from the Japanese word for 'comic', much of its popularity is down to the traditional content of the comic-strip stories. Invariably they involve a moralistic tale of good versus evil, in which good inevitably claims victory. Along the way, characters face challenges and encounter strange beings that look set to obstruct their goals. What is unique about the form is the element of rebellion in the way that characters are portrayed: hideous-looking monsters turn out to be innocent, weak and friendly, while an attractive, sporty young girl might be a devious, dangerous foe. Many of the stories involve trickery and duplicity as complex characters use

special powers, weapons and strategies to pitch their wits against one another.

the mecha element

Alongside the 'human' looking characters in these manga stories are all manner of 'mecha' characters –

Robotic characters feature often in manga comic strips. They often take human or animal forms.

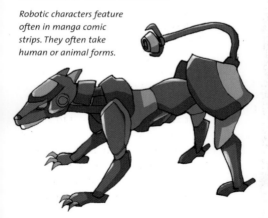

robots designed especially for fighting, serving or working in many fields. Very often their characteristics reflect specific functions and can be human or animal-like in nature – or completely other-worldly.

In order to draw them, you will need some very basic art materials (see pages 12–19) but a vivid imagination is just as important and that is where this book comes in.

Step by step, the instructions on the following pages show you how to draw over 30 convincing mecha characters – from the very first rough sketch to finished artwork. You will learn how to draw figures with a host of different functions and in a range of different postures, making sure you get proportion and perspective right. There are also special features on drawing hands and feet, joints and accessories.

mecha inspiration

When it comes to inspiration for your characters, there really are no limits beyond your own imagination. You can use an animal, plant or even a building as your starting point and can mix and match elements to suit your design. For example you can blend the typical form of a dog with human features in order to give more depth to its personality. Alternatively, you could use industrial objects as your inspiration, building weaponry into a design for a military mecha, for example. There are no rules.

This mecha is very closely related to the human form in terms of proportion and features. It has a human-looking face and hands.

equipment

In order to create your own manga art, it is a good idea to invest in a range of materials and equipment. The basics include paper for sketches and finished artworks, pencils and inking pens for drawing and colour pencils, markers or paints for finishing off. There are also a handful of drawing aids that will help produce more professional results.

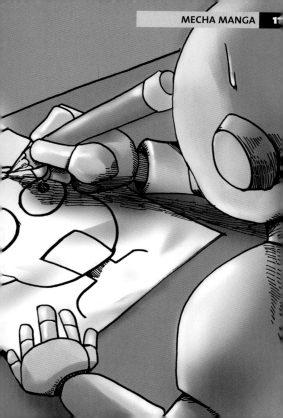

drawing

Every mecha character must start with a pencil sketch – this is essential. You need to build each figure gradually, starting with a structural guide and adding physical features, then armour, in layers. The best way to do this effectively is by using a pencil.

pencils

You can use a traditional graphite pencil or a mechanical one according to preference. The advantages of the latter are that it comes in different widths and does not need sharpening. Both sorts are available in a range of hard leads (1H to 6H) or soft leads (1B to 6B); the higher the number in each case, the harder or softer the pencil. An HB pencil is halfway between the two ranges and will give you accurate hand-drawn lines. For freer, looser sketches, opt for something softer – say a 2B lead. Some of the sketches in this book are drawn using a blue lead. This is particularly useful if you intend to produce your artworks digitally, as blue does not show up when photocopied or scanned. If you opt for a traditional graphite pencil, you will also need a pencil sharpener.

An eraser or putty eraser is an essential tool. Use it to remove and correct unwanted lines or to white-out those areas that need highlights. Choose a good-quality eraser that will not smudge your work.

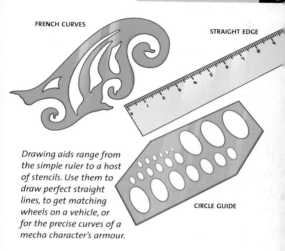

FRENCH CURVES

STRAIGHT EDGE

CIRCLE GUIDE

Drawing aids range from the simple ruler to a host of stencils. Use them to draw perfect straight lines, to get matching wheels on a vehicle, or for the precise curves of a mecha character's armour.

drawing aids and guides

The tips in this book show you how to draw convincing mecha characters from scratch by hand. There may be times, however, when drawing by hand proves a little too difficult. Say your composition features a futuristic city scape; you might want to use a ruler to render the straight edges of the buildings more accurately. The same could be true if you wanted to draw more precise geometric shapes – a true circle for the sun, for example.

inking and colouring

Once you have drawn your mecha character in pencil, you can start to add colour. This is where you can really let your imagination run free. There are numerous art materials available for inking and colouring and it pays to find out which ones suit you best.

inking

A good mecha character relies on having a crisp, clean, solid black outline and the best way to achieve this is by using ink. You have two choices here. First is the more traditional technique, using pen and ink. This involves a nib with an ink cartridge, which you mount in a pen holder. The benefit of using this method is that you can vary the thickness of the strokes you draw, depending on how much pressure you apply as you work. You also tend to get a high-quality ink. The alternative to using pen and ink is the felt-tipped drawing pen, which comes in a range of widths. A thin-nibbed pen (0.5mm) is best, but it is also a good idea to have a medium-nibbed pen (0.8mm) for more solid blocks of ink. Whichever option you go for, make sure the ink is quick-drying and/or waterproof so that it does not run or smudge as you work.

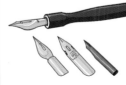

Pen holders and nibs come in different sizes. It is good to have a ready supply of nibs, as they wear down quickly and lose their edge.

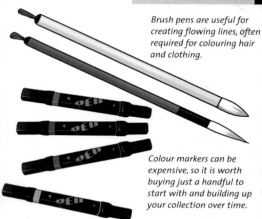

Brush pens are useful for creating flowing lines, often required for colouring hair and clothing.

Colour markers can be expensive, so it is worth buying just a handful to start with and building up your collection over time.

colouring

There are various options available to you when it comes to colouring your work. The most popular method is to use marker pens. These are fast-drying and available in many colours. You can use them to build up layers of colour, which really helps when it comes to creating shading in, say, hair or clothing. You can also use colour pencils and paints very effectively (gouache or watercolour). Colour pencils and watercolours are probably the most effective media for building up areas of tone – say for skin – and also for blending colours here and there. White gouache is very useful for creating highlights and is best applied with a brush.

papers

It is difficult to imagine that you will have the perfect idea for a character every time you want to draw a manga scenario. These need to be worked at – not just in terms of appearance – but also in terms of personality. It is a good idea, therefore, to have a sketchbook to hand so that you can try out different ideas. Tracing paper is best for this, as its smooth surface allows you to sketch more freely. You can also erase unwanted lines several times over without tearing the paper. A recommended weight for tracing paper is 90gsm.

Having sketched out a few ideas you will want to start on a proper composition, where you move from pencil outline to inked drawing to finished coloured art. If you are tracing over a sketch you have already made, it is best to use paper that is only slightly opaque, say 60gsm. In order to stop your colours bleeding as you work, it is important that you buy 'marker' or 'layout' paper. Both of these are good at holding colour without it running over your inked lines and blurring the edges. 'Drawing' paper is your best option if you are using just coloured pencils with the inked outline, while watercolour paper is, of course, ideal for painting with watercolour – a heavyweight paper will hold wet paint and colour marker well. You also have a choice of textures here.

It is always best to allow space around the edge of your composition, to make sure that the illustration will fill the frame.

using a computer

The focus of this book is in learning how to draw and colour manga characters by hand. Gradually, by practising the steps over and again you will find that your sketches come easily and the more difficult features, such as hands, feet and eyes, begin to look more convincing. Once that happens, you will be confident enough to expand on the range of characters you draw. You might even begin to compose cartoon strips of your own or, at the very least, draw compositions in which several characters interact with each other – such as a battle scene.

Once you reach this stage, you might find it useful to start using a computer alongside your regular art materials. Used with a software program, like Adobe Photoshop, you can colour scanned-in sketches quickly and easily. You will also have a much wider range of colours to use and can experiment at will.

Any home computer can be used for colouring your manga sketches in order to produce finished art.

You can input a drawing straight into a computer program by using a graphics tablet and pen. The tablet plugs into your computer, much like a keyboard or mouse.

Moving one step further, a computer can save you a lot of time and energy when it comes to producing comic strips. Most software programs enable you to build a picture in layers. This means that you could have a general background layer – say a mountainous landscape – that always stays the same, plus a number of subsequent layers on which you can build your story. For example, you could use one layer for activity that takes place in the sky and another layer for activity that takes place on the ground. This means that you can create numerous frames simply by making changes to one layer, while leaving the others as they are. There is still a lot of work involved, but working this way does save you from having to draw the entire frame from scratch each time.

Of course, following this path means that you must invest in a computer if you don't already have one. You will also need a scanner and the relevant software. All of this can be expensive and it is worth getting your hand-drawn sketches up to a fairly accomplished level before investing too much money.

human forms

Many of the service mechas are close to the human form in both shape and proportion.

2 Take inspiration from the world around you to give human-looking mechas anything but human features. These shoulder plates were inspired by a stiletto shoe.

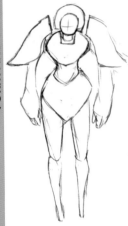

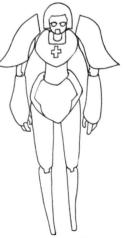

1 Figures like this begin with a pencil drawing of the basic human form. You can use a photograph to help get the proportions right. Mecha-like features are then added to this initial structure.

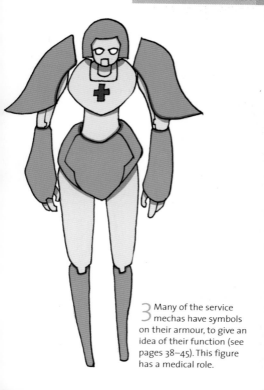

3 Many of the service mechas have symbols on their armour, to give an idea of their function (see pages 38–45). This figure has a medical role.

animal inspiration

A wolf-like mecha that combines the features of a wild animal with the characteristics of a human being.

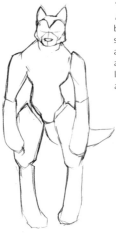

2 This more detailed sketch shows how the body is divided into simple sections – head, upper arm, lower arm, chest, abdomen, upper leg, lower leg – each with joints to allow for movement.

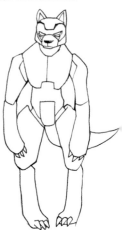

1 For figures like this, it pays to start with an almost human structure. This way you can make sure the mecha's head, body and limbs all have good proportions.

3 Key to all mecha figures are their armour plates. In most cases, your lines will be more angular and rigid than when drawing human figures.

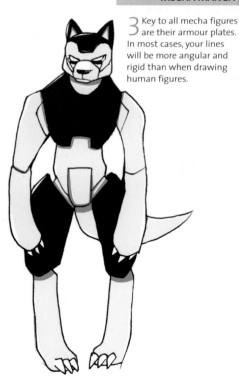

industrial inspiration

Industrial mechas share characteristics with human forms, but are streamlined to suit specific functions.

2 Typical industrial mecha features are the protective helmet, the articulated spine to aid a bending motion and simple 'hands', shaped for a single activity.

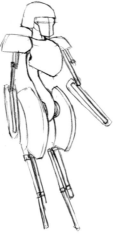

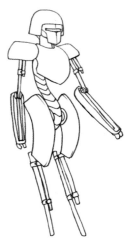

1 Despite looking unlike a human being, this industrial mecha does have human proportions – the head is about one-seventh of the body size and the legs just over half.

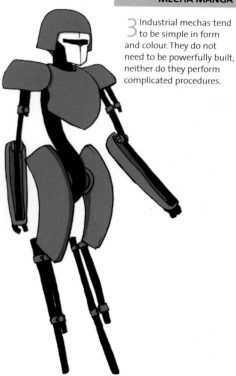

3 Industrial mechas tend to be simple in form and colour. They do not need to be powerfully built, neither do they perform complicated procedures.

balance in human forms

A successful mecha character relies on realistic proportions, accurate perspective and a good sense of balance.

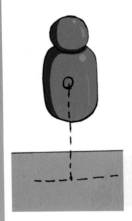

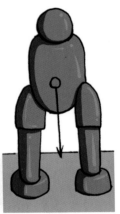

Draw a horizon, this will help you determine the centre of gravity. Sketch the head and torso of your figure, then draw a vertical line from the centre of the torso to the ground. Draw a horizontal line running perpendicular to the vertical one.

The horizontal line should extend to the full width of the torso. When you draw the legs coming out of the body, each should be centred at one end of the horizontal line. This will help to create a sense of balance.

RIGHT You can use the same process to determine perspective when drawing characters from side or three-quarter views.

BELOW If you shift the balance of the character, as below, you must find the new centre of gravity.

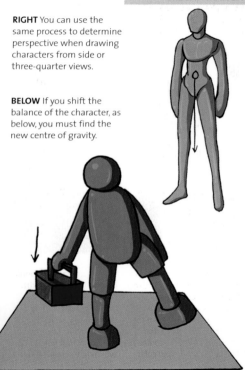

balance in non-human forms

The rules for perspective, proportion and balance are universal and apply to animals and abstract forms alike.

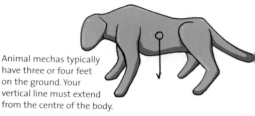

Animal mechas typically have three or four feet on the ground. Your vertical line must extend from the centre of the body.

You want the vertical line to reach the ground at the mid-point between the grounded feet.

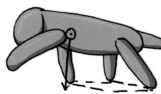

If an animal is running, the line of gravity will shift to accommodate the new leg positions.

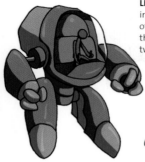

LEFT A well-balanced industrial mecha. The line of gravity was found using the same process as for a two-legged mecha.

RIGHT Finding the line of gravity can be useful when drawing figures that require perspective.

LEFT The line of gravity for this mecha was found using the same process as for a four-legged mecha.

GALLERY

RIGHT An anonymous-looking industrial mecha, with barely any facial features and very little detail to his armour. He carries his tool – a chainsaw – on his back.

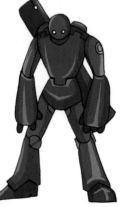

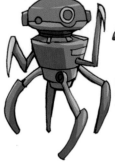

LEFT An abstract insect form with asymmetrical facial features and highly articulate limbs.

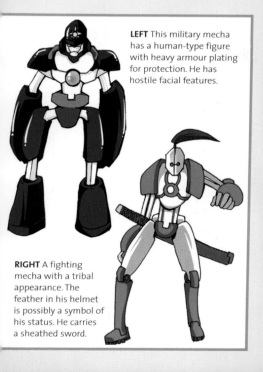

LEFT This military mecha has a human-type figure with heavy armour plating for protection. He has hostile facial features.

RIGHT A fighting mecha with a tribal appearance. The feather in his helmet is possibly a symbol of his status. He carries a sheathed sword.

faces and hands

Faces and hands take many forms – from the blank look of a service mecha to the tool-like fingers of a factory mecha.

2 Facial features often need to reflect a mecha's duty. If the mecha does not communicate with people, its face may be quite abstract – say a camera hidden by a mask.

1 Human-looking facial expressions reflect a character's personality. An assassin should be cold and ruthless while a domestic mecha will look honest and warm. All expressions are fixed.

4 The industrial-type mecha invariably has tool-shaped hands, while animal-type mechas just need animal paws.

3 Hands are usually an important working part of a mecha's design. Human-shaped hands suggest that the mecha can use tools that are normally used by a human.

arms and legs

Arms and legs vary widely, depending on the function of the mecha they are designed for.

2 Not all mecha arms and legs need to have human-type joints. Sometimes they can employ flexible tubes to aid mobility.

1 Some arms and legs combine rigid metals with soft, man-made muscles. This gives the mecha greater flexibility.

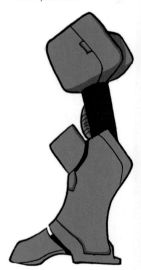

4 Arms and legs made exclusively from hard materials also have big joints to make the mecha more powerful.

3 For more sophisticated mechas, arms and legs are simply man-made versions of human ones, with greater strength and maximum flexibility.

joints

Mecha joints range from the very basic to the highly articulate, depending on the character's role.

1 Many mecha joints are fairly rudimentary. Often they allow movement in just one direction.

2 Industrial mechas tend to have joints and limbs that have more in common with machinery. This is largely down to the fact that they need to be ultra-functional.

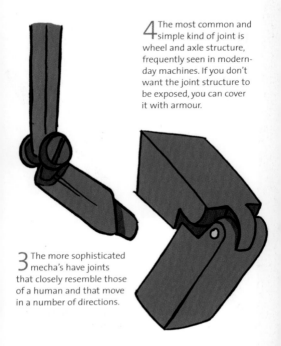

4 The most common and simple kind of joint is wheel and axle structure, frequently seen in modern-day machines. If you don't want the joint structure to be exposed, you can cover it with armour.

3 The more sophisticated mecha's have joints that closely resemble those of a human and that move in a number of directions.

symbol design

Symbols are key features of mecha design and help to identify a character's duty, personality or profession.

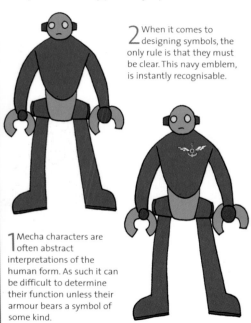

2 When it comes to designing symbols, the only rule is that they must be clear. This navy emblem, is instantly recognisable.

1 Mecha characters are often abstract interpretations of the human form. As such it can be difficult to determine their function unless their armour bears a symbol of some kind.

4 Have fun with your symbols. A bar code could be used for a mecha waiting to be bought in a supermarket.

3 The electricity and warning symbols suggest that this mecha works in industry, maybe repairing the national grid system.

symbol design continued

1 Animal forms can be used to denote specific characteristic traits. For example, an eagle stands for decisiveness and militancy.

2 Symbols might be used to show specific industrial employment, in this case mining.

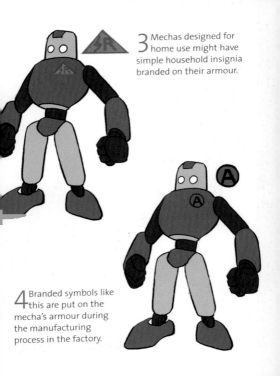

3 Mechas designed for home use might have simple household insignia branded on their armour.

4 Branded symbols like this are put on the mecha's armour during the manufacturing process in the factory.

symbol design continued

1 A military mecha might have a division symbol on its armour – often a pictorial image with a serial number.

2 Fighting mechas might bear symbols that show allegiance to a specific cause or group.

3 Armorial symbols are used for mecha knights. They signify lineage, nobility, allegiance to a monarch and virtuous pursuits.

4 Armorial symbols might appear on a knight's shield. They are also often shield shaped.

symbol design continued

1 Japanese style symbols will convey information about the family. They can stand for loyalty and courage. The design of the symbol can be either very simple or complicated, this symbol is based on Japanese calligraphy.

2 Geometric symbols are widely used. They can be designed in a way that will help to accentuate the angular lines of a mecha figure, reinforcing their power and strength.

accessories

The fun in designing mechas lies in the fact that you can invent tools and accessories that humans can only dream of.

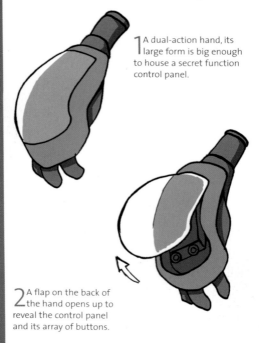

1 A dual-action hand, its large form is big enough to house a secret function control panel.

2 A flap on the back of the hand opens up to reveal the control panel and its array of buttons.

1 Some mechas have metamorphic qualities, whereby they can adapt their structures to suit a given situation.

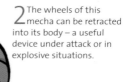

2 The wheels of this mecha can be retracted into its body – a useful device under attack or in explosive situations.

cold weapons

Although most mechas have advanced weapons, there are a number who use traditional cold weapons for close combat.

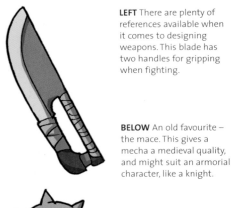

LEFT There are plenty of references available when it comes to designing weapons. This blade has two handles for gripping when fighting.

BELOW An old favourite – the mace. This gives a mecha a medieval quality, and might suit an armorial character, like a knight.

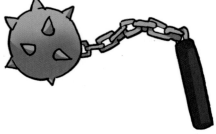

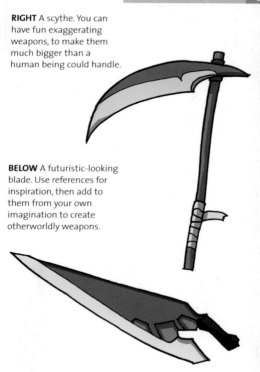

RIGHT A scythe. You can have fun exaggerating weapons, to make them much bigger than a human being could handle.

BELOW A futuristic-looking blade. Use references for inspiration, then add to them from your own imagination to create otherworldly weapons.

firearms

Ranging from the basic to the elaborate, firearms feature widely in manga comic strips.

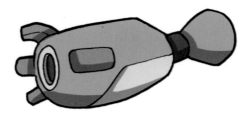

ABOVE Quite often weaponry is integral to a mecha's body, in this case built into an arm or mounted on the back.

BELOW You can have fun giving a basic weapon a more futuristic shape and appearance.

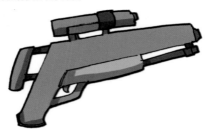

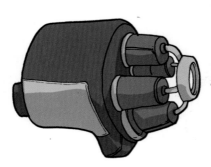

ABOVE Use your imagination to design firearms that have an otherworldly look to them.

RIGHT Mecha's that have to go into battle regularly might have whole limbs that operate as firearms.

tools as weapons

Some tools can be used as weapons as well, which gives them a dual purpose.

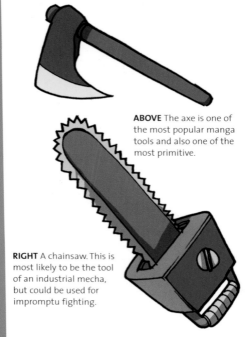

ABOVE The axe is one of the most popular manga tools and also one of the most primitive.

RIGHT A chainsaw. This is most likely to be the tool of an industrial mecha, but could be used for impromptu fighting.

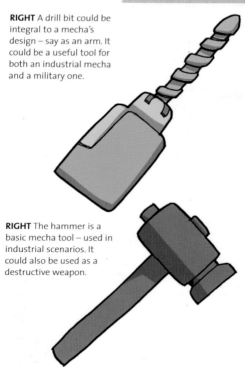

RIGHT A drill bit could be integral to a mecha's design – say as an arm. It could be a useful tool for both an industrial mecha and a military one.

RIGHT The hammer is a basic mecha tool – used in industrial scenarios. It could also be used as a destructive weapon.

sci-fi weapons

Let your imagination run riot when it comes to designing a wide range of sci-fi weapons for your mechas to use.

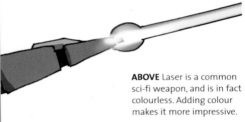

ABOVE Laser is a common sci-fi weapon, and is in fact colourless. Adding colour makes it more impressive.

BELOW The Ion cannon is a sci-fi superweapon, capable of destroying large targets, including vehicles and substations.

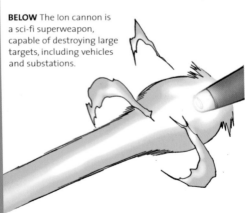

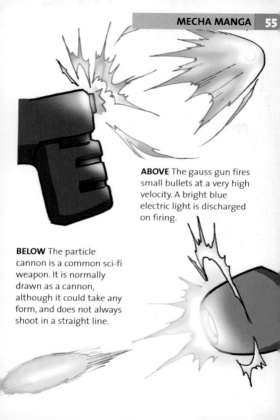

ABOVE The gauss gun fires small bullets at a very high velocity. A bright blue electric light is discharged on firing.

BELOW The particle cannon is a common sci-fi weapon. It is normally drawn as a cannon, although it could take any form, and does not always shoot in a straight line.

sci-fi weapons continued

ABOVE This is a Tesla gun, a directed-energy weapon that fires lethal rays.

ABOVE This weapon shoots plasma that can melt metal and burn humans to dust in an instant.

LEFT A lightsabre. Commonplace in sci-fi films. This is a sword where the blade is replaced by an energy beam that can slice through most substances.

BELOW An electromagnetic pulse (EMP). On exploding, this produces a burst of electromagnetic radiation.

textures

For three-dimensional figures, it is important to be able to show how different textures behave in light and shade.

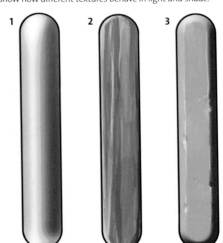

Mechas are not made exclusively from solid steel, but from a range of different materials. The same shape and structure can change dramatically, depending on what it is made from. Painted metals (1) tend to be smooth, flat surfaces with sharp highlights where they catch the light; wood (2) absorbs rather than reflects light, giving it a

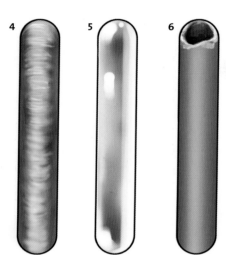

dull surface. It also has the texture of woodgrain; hard PVC (**3**) is generally flat with strong shadows; polished metals like copper (**4**) and steel are reflective, but with soft highlights; glass (**5**) is highly reflective with harsh lines and pure white highlights; plastics (**6**) absorb less light, like wood, and tend to be matte with very soft, graduated highlights.

how to draw metal

Since the vast majority of mecha surfaces are made from metal, it is important to be able to render it accurately.

1 Every mecha illustration begins with a pencil outline which you go over with black ink.

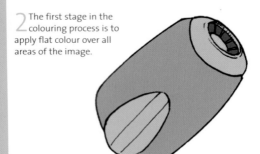

2 The first stage in the colouring process is to apply flat colour over all areas of the image.

3 Put in some very basic highlights, countered by areas of shadow. Add the colour in such a way that you give the object its three-dimensional appearance.

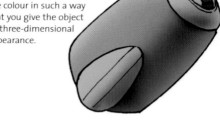

4 Give the highlights more emphasis. This will help to create the shiny quality of the metal.

how to draw a flame

Mechas often rely on rocket projectors for extra mobility.
They are very simple to colour effectively.

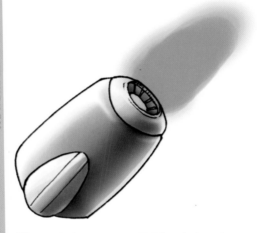

1 Draw and colour your object before starting on the flame. Put in basic highlights and shadows that give the object its three-dimensions. Then use pencil to lightly sketch in the outline flame.

2 Colour the basic shape of the red flame first. Blur the edges of the flame and make it slightly narrower at the top to give it some shape.

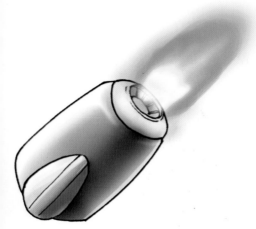

3 Create the core of the flame with a very bright yellow–white area to give it the intensity of burning fuel. Again, it will need to be blurred at the edges to make it more convincing.

4 This flame has been coloured digitally. If you are going to colour it with marker pens, you will need to start with the lighter areas of white and yellow, then work up the stronger reds of the flame.

how to draw a laser

A laser has a more defined shape than a rocket flame (see page 62), although it is rendered in much the same way.

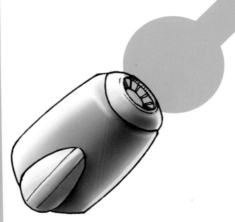

1 Draw and colour your object before starting on the laser.

2 Colour the basic laser form. Use blue and shape the beam in such a way that it is bigger at the base. Use geometric shapes and keep your lines crisp and clean.

3 Use pure white to fill the core of the laser beam. Blur the edges a little to give the beam its three-dimensional appearance.

4 The beam of this laser has been coloured digitally If you are going to use marker pens, you will need to start with the whites and lighter blues, then work up the stronger colours of the beam.

mecha world

Welcome to the world of robots, home to mechas from all walks of life – the factory, the battlefield, even outer space. You will find loyal servants alongside spying hounds and war machines of the highest order. Draw them, colour them and adapt them to create mechas of your own.

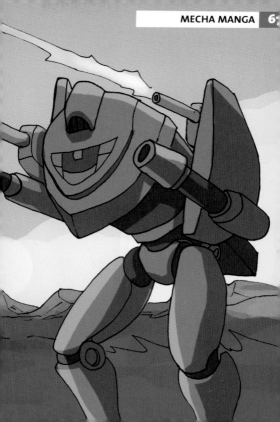

male body mecha

This is the simplest mecha form, based on the male human body and sharing a number of characteristics.

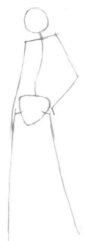

2 Draw in very simple shapes to show where all the joints should be. Add four more for the hands and feet.

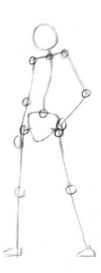

1 Start by drawing a very basic structure for your figure, using pencil. Try to get the proportions right – typically the head will make up one-seventh of the body, and the legs half.

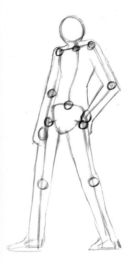

3 Use your basic structure to draw a full outline for your figure. Keep it fairly realistic, while focusing on proportions and perspective.

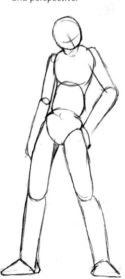

4 With that done, you can begin to consider the mechanical aspect of your figure. Divide the body into separate moving parts, and give the shapes a more manufactured look.

▸▸

male body mecha continued

5 Use your imagination to give the figure some character. This version has a thinner waist than a human, to allow for swift movements. The hips are bigger, helping to support the strong legs.

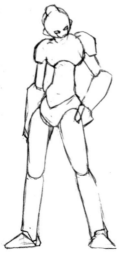

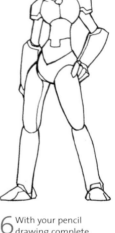

6 With your pencil drawing complete, you can go over your outline using black ink. Add any final details, such as the decorative or finer details on the armour.

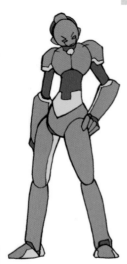

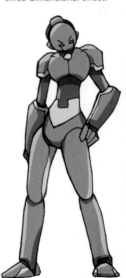

8 Consider where the light is coming from and add highlights to show where it is reflected by the mecha's armour. Add shadows to complete the three-dimensional effect.

7 Colour up your image. Blue-grey is the archetypal colour for a metallic male figure. Apply flat colour to start with, and colour all areas of the figure.

female body mecha

Based on the female human body, this mecha is generally more curvaceous than the male version (see page 71).

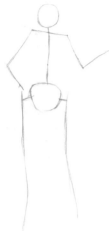

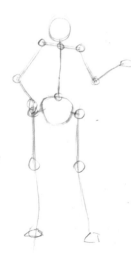

2 Draw in very simple shapes to show where all the joints should be. Add four more for the hands and feet.

1 Using pencil, draw a very basic structure for your figure. Think about proportion as you do this. As with the male version, the head makes up one-seventh of the body, and the legs roughly half.

3 Give your figure a fuller outline now, keeping it fairly realistic. Focus on getting the proportions and perspective right.

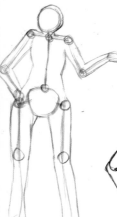

4 Build on the mechanical aspect of your figure. Divide the body into separate moving parts, and give the shapes a more factory-made look. Draw guidelines for positioning the facial features.

▶▶

female body mecha continued

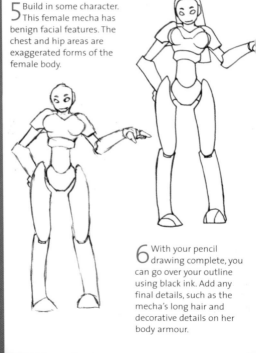

5 Build in some character. This female mecha has benign facial features. The chest and hip areas are exaggerated forms of the female body.

6 With your pencil drawing complete, you can go over your outline using black ink. Add any final details, such as the mecha's long hair and decorative details on her body armour.

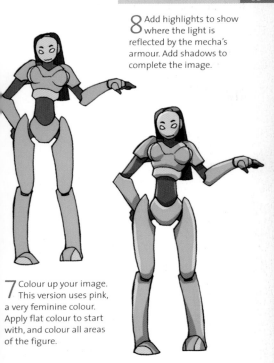

8 Add highlights to show where the light is reflected by the mecha's armour. Add shadows to complete the image.

7 Colour up your image. This version uses pink, a very feminine colour. Apply flat colour to start with, and colour all areas of the figure.

child body mecha

This mecha is based on the body shape of a human child and so is slightly rounder than the adult versions.

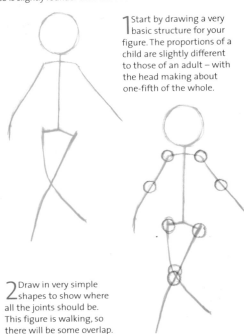

1 Start by drawing a very basic structure for your figure. The proportions of a child are slightly different to those of an adult – with the head making about one-fifth of the whole.

2 Draw in very simple shapes to show where all the joints should be. This figure is walking, so there will be some overlap.

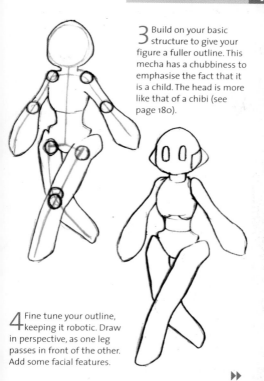

3 Build on your basic structure to give your figure a fuller outline. This mecha has a chubbiness to emphasise the fact that it is a child. The head is more like that of a chibi (see page 180).

4 Fine tune your outline, keeping it robotic. Draw in perspective, as one leg passes in front of the other. Add some facial features.

▶▶

child body mecha continued

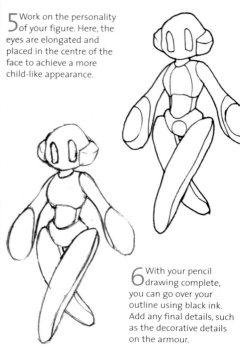

5 Work on the personality of your figure. Here, the eyes are elongated and placed in the centre of the face to achieve a more child-like appearance.

6 With your pencil drawing complete, you can go over your outline using black ink. Add any final details, such as the decorative details on the armour.

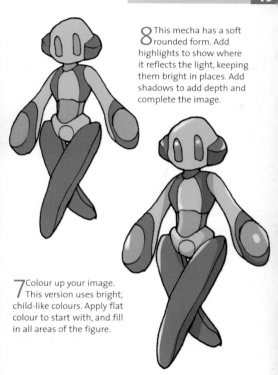

8 This mecha has a soft rounded form. Add highlights to show where it reflects the light, keeping them bright in places. Add shadows to add depth and complete the image.

7 Colour up your image. This version uses bright, child-like colours. Apply flat colour to start with, and fill in all areas of the figure.

GALLERY

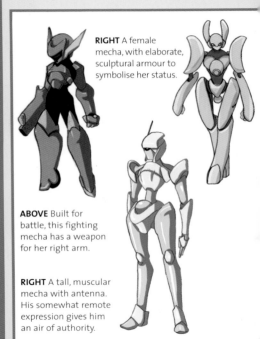

RIGHT A female mecha, with elaborate, sculptural armour to symbolise her status.

ABOVE Built for battle, this fighting mecha has a weapon for her right arm.

RIGHT A tall, muscular mecha with antenna. His somewhat remote expression gives him an air of authority.

RIGHT Built for the factory floor, this industrial mecha has huge mechanical arms and legs.

LEFT Bearing the closest resemblance to a normal man, this mecha has a human face.

RIGHT A mecha with extremely lean, long and powerful limbs.

basic fighting mecha

Mass-produced on a large scale, the basic fighting mecha is designed for low-level fighting.

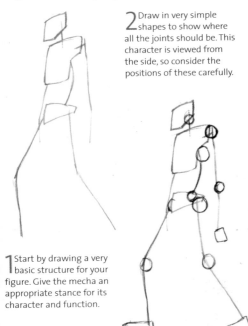

2 Draw in very simple shapes to show where all the joints should be. This character is viewed from the side, so consider the positions of these carefully.

1 Start by drawing a very basic structure for your figure. Give the mecha an appropriate stance for its character and function.

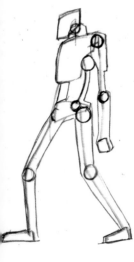

4 Divide the body into separate moving parts, keeping the shapes square and angular. Your figure should resemble a lean fighting machine.

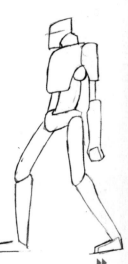

3 Use your basic structure to draw a full outline for your figure. The lines are less rounded than those for the more human-looking mechas (see pages 71, 75 and 79).

▶▶

basic fighting mecha continued

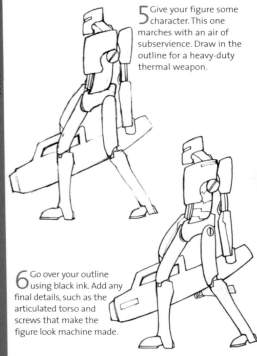

5 Give your figure some character. This one marches with an air of subservience. Draw in the outline for a heavy-duty thermal weapon.

6 Go over your outline using black ink. Add any final details, such as the articulated torso and screws that make the figure look machine made.

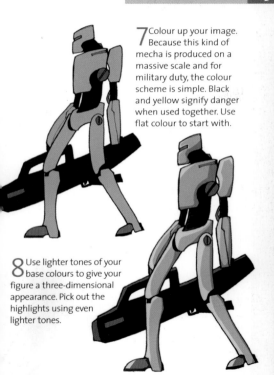

7 Colour up your image. Because this kind of mecha is produced on a massive scale and for military duty, the colour scheme is simple. Black and yellow signify danger when used together. Use flat colour to start with.

8 Use lighter tones of your base colours to give your figure a three-dimensional appearance. Pick out the highlights using even lighter tones.

police mecha

Fighting for justice, this police mecha adopts a tall, upright authoritative pose.

2 Draw in very simple shapes to show where all the joints should be. Add four more for the hands and feet.

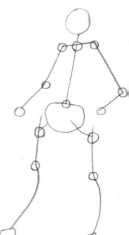

1 Start by drawing a very basic structure for your figure. Have a picture of the finished body shape in mind as you do so. For example, draw the arms so that they can hold a gun.

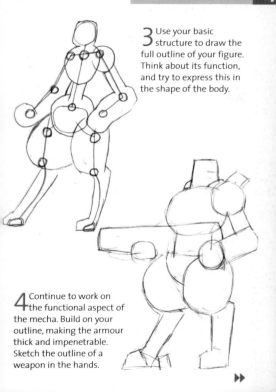

3 Use your basic structure to draw the full outline of your figure. Think about its function, and try to express this in the shape of the body.

4 Continue to work on the functional aspect of the mecha. Build on your outline, making the armour thick and impenetrable. Sketch the outline of a weapon in the hands.

police mecha continued

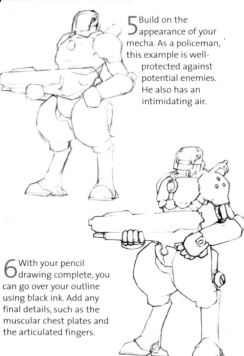

5 Build on the appearance of your mecha. As a policeman, this example is well-protected against potential enemies. He also has an intimidating air.

6 With your pencil drawing complete, you can go over your outline using black ink. Add any final details, such as the muscular chest plates and the articulated fingers.

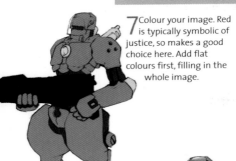

7 Colour your image. Red is typically symbolic of justice, so makes a good choice here. Add flat colours first, filling in the whole image.

8 Take care with light and shade. Shadows are very dark and well-defined on the hard surfaces of the gun. Highlights on the police mecha's armour are softer, emphasising the more curvaceous form.

heavy weaponry mecha

Designed primarily for firing lethal weapons, this top-heavy mecha is bulky and slow.

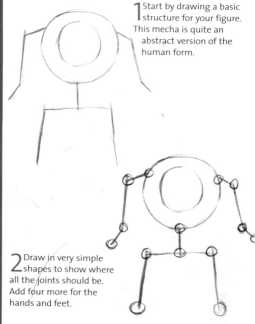

1 Start by drawing a basic structure for your figure. This mecha is quite an abstract version of the human form.

2 Draw in very simple shapes to show where all the joints should be. Add four more for the hands and feet.

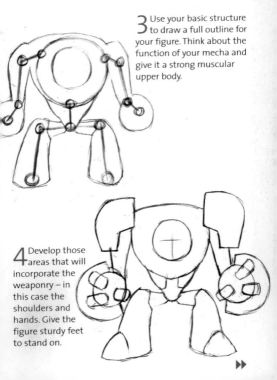

3 Use your basic structure to draw a full outline for your figure. Think about the function of your mecha and give it a strong muscular upper body.

4 Develop those areas that will incorporate the weaponry – in this case the shoulders and hands. Give the figure sturdy feet to stand on.

▶▶

heavy weaponry mecha continued

5 Use your imagination to give the figure some character. In this case the 'head' is set low in order to accommodate the cannons on the shoulders.

6 With your pencil drawing complete, you can go over your outline using black ink. Fine tune the facial feature and the screws that give him a more machine-made appearance.

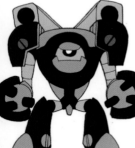

7 Colour up your image, applying flat colours throughout to start with. Blue-black and yellow signal danger.

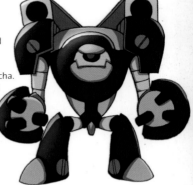

8 Use light and shade to emphasise the shape of the mecha. His bulky form is also quite rounded, so highlights should be strong on the curved surfaces.

tank mecha

Based on a regular tank, this four-legged version is well-built and sturdy. Legs provide greater mobility than tracks.

1 Start by drawing a very basic structure. Consider your viewpoint and get the perspective right.

2 This mecha is in motion. Draw basic shapes at the main points of articulation.

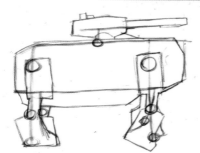

3 Give your mecha an outline. This version moves on legs rather than wheels or caterpillar tracks.

4 Give your outline more definition. Develop the front of the tank and the shape of the gun.

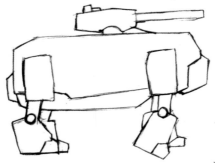

▶▶

tank mecha continued

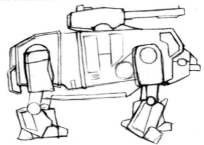

5 Give your tank some character. In addition to legs, this tank has a snout-like nose and a stubby tail.

6 Go over your outline in black ink. Add all those details that give the machine its military appearance.

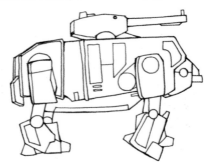

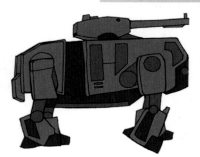

7 Colour up your image. This is a military vehicle, so has a monochromatic look to it. Fill the whole image with flat colour.

8 Use bright highlights to emphasise the sheen of the metallic surfaces and drop in a few dark shadows.

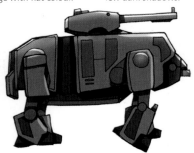

spy mecha

This spy mecha has a menacing air. Its large all-seeing 'eye' is the focal point of the figure.

2 Draw in very simple shapes to show where all the joints should be, bearing in mind that the 'face' is set lower than the shoulders.

1 Start by drawing a very basic structure for your figure. This example is loosely based on the human form and has similar proportions.

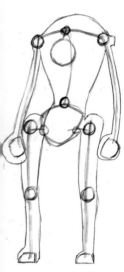

4 Continue to work on the body, dividing the limbs into sections and giving definition to the abdominal area. Draw large, manipulative hands.

3 Develop the arms and legs. This is not a fighting machine, so limbs are slim and flexible. The spying eye – a camera – dominates the upper half of the mecha's body.

▶▶

spy mecha continued

5 Consider the character of your figure. The lack of recognisable facial features gives this version an impersonal, anonymous personality.

6 With your pencil drawing complete, you can go over your outline using black ink. Add any final details, such as the articulated torso.

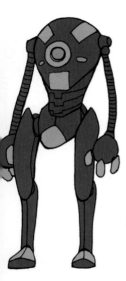

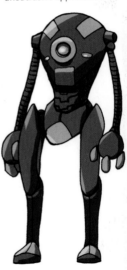

8 Keep the colours dull, adding minimal highlights in curved areas, but adding more shade to help with an unobtrusive appearance.

7 Colour your image. This brown and pink scheme gives the mecha a dull look, and avoids him drawing attention to himself. Apply flat colours first.

ninja mecha

With its masked face and huge sword, this mecha has much in common with the traditional Japanese ninja mercenaries.

1 Start by drawing a very basic structure for your figure. Have a picture of the finished body shape in your mind as you do so – lean, slim and flexible.

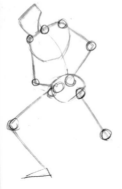

2 Draw in very simple shapes to show where all the joints should be. This character is viewed from the side, so consider the positions of these carefully.

3 Use your basic structure to draw a full outline for your figure. Keep the outline fairly human, while focusing on proportions and perspective.

4 Build on the shape of your figure. Divide the body into sections. Keep your lines rigid and angular to give the character its lean, precision-made appearance. Finalise the shape of the mecha's mask.

▶▶

ninja mecha continued

5 Add details that complete the ninja look; the lean body armour and a long, flat-bladed sword. Use strong, sweeping lines to emphasise the character's confidence and fearlessness.

6 With your pencil drawing complete, you can go over your outline using black ink. Keep your lines clean and fluid to give this fighting machine its stealthy appearance.

7 Colour your image. The dark purple and red combination gives this ninja an air of menacing invincibility. Apply flat colour throughout.

8 Pick out strong highlights on the armour in order to emphasise its sheerness and glossy, painted-steel finish. Make the darks even darker to complete the effect.

assassin mecha

A little humpbacked, this mecha is nevertheless stealthy.
His weapon hands fire swiftly and quietly.

1 Start by drawing a basic
structure for your figure.
This mecha is an abstract
version of the human form,
and is in motion.

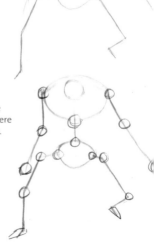

2 Draw in very simple
shapes to show where
all the joints should be.
Add four more for the
hands and feet.

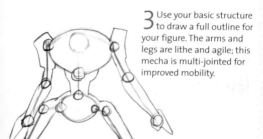

3 Use your basic structure to draw a full outline for your figure. The arms and legs are lithe and agile; this mecha is multi-jointed for improved mobility.

4 Develop the assassin mecha's weapon hands. These are lean and efficient extensions of his arms. Give him small flexible feet, ideal for running on.

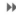

assassin mecha continued

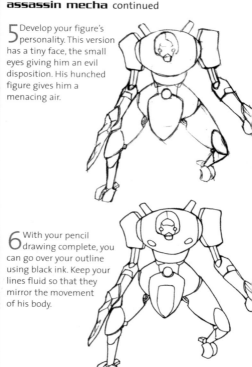

5 Develop your figure's personality. This version has a tiny face, the small eyes giving him an evil disposition. His hunched figure gives him a menacing air.

6 With your pencil drawing complete, you can go over your outline using black ink. Keep your lines fluid so that they mirror the movement of his body.

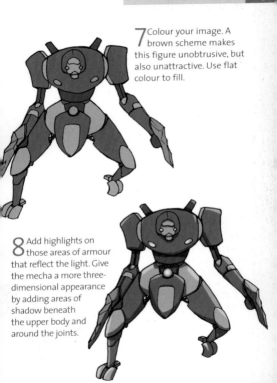

7 Colour your image. A brown scheme makes this figure unobtrusive, but also unattractive. Use flat colour to fill.

8 Add highlights on those areas of armour that reflect the light. Give the mecha a more three-dimensional appearance by adding areas of shadow beneath the upper body and around the joints.

space fighting mecha

This is an abstract form, engaged in fighting on distant planets. Its weapons are integral to its design.

1 Start by drawing a basic structure for your mecha. Consider how its shape might best cope with the uneven surfaces of undeveloped planets.

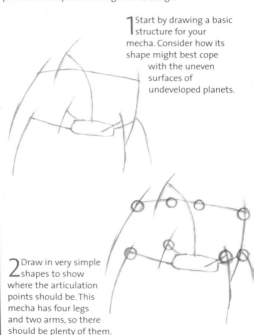

2 Draw in very simple shapes to show where the articulation points should be. This mecha has four legs and two arms, so there should be plenty of them.

3 Use your basic structure to draw an outline for your figure. Here the legs are short and sturdy, while the arms are large and sweeping. The body of the mecha could house a person to act as operator.

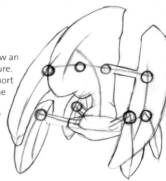

4 Develop those areas that will incorporate the weaponry – in this case short barrels protruding from the mecha's arms.

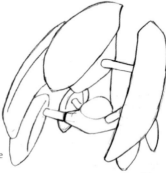

▶▶

space fighting mecha continued

5 Fine tune your design, adding details like the articulated spine for improved flexibility. Draw in some lines to make the mecha look more three-dimensional.

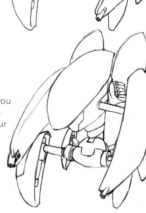

6 With your pencil drawing complete, you can go over your outline using black ink. Keep your lines sharp and crisp.

7 Colour up your image. This example has a colour scheme that might offer camouflage on dry, rocky planets. Keep the colour flat at this stage.

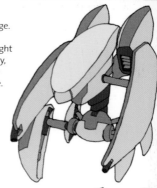

8 Add strong shadows on those surfaces shielded from the light. This will help to suggest the cloudless atmosphere of the planet. Drop subtle highlights on the glazed area to render the glass accurately.

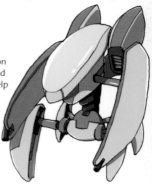

space warrior mecha

This is a very swift and flexible, winged space mecha that can shoot from long distances.

2 Draw in very simple shapes to show where all the joints should be. Add four more for the hands and feet.

1 Start by drawing a basic structure for your figure. Based on the human form, this mecha has a smaller head, proportionately, to the rest of its body.

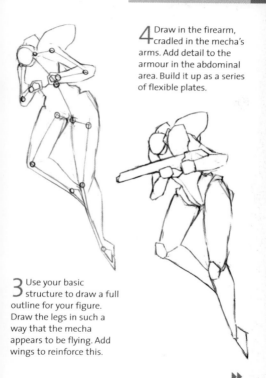

4 Draw in the firearm, cradled in the mecha's arms. Add detail to the armour in the abdominal area. Build it up as a series of flexible plates.

3 Use your basic structure to draw a full outline for your figure. Draw the legs in such a way that the mecha appears to be flying. Add wings to reinforce this.

▶▶

space warrior mecha continued

5 Draw additional flexible plates on the arms and legs. This mecha needs to move swiftly, so all the joints need to be free from obstruction.

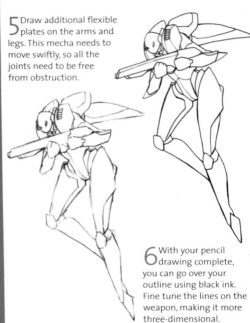

6 With your pencil drawing complete, you can go over your outline using black ink. Fine tune the lines on the weapon, making it more three-dimensional.

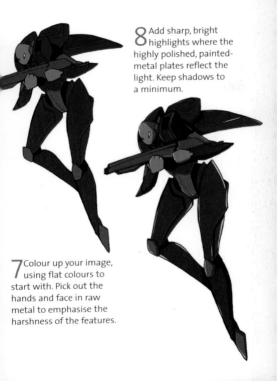

8 Add sharp, bright highlights where the highly polished, painted-metal plates reflect the light. Keep shadows to a minimum.

7 Colour up your image, using flat colours to start with. Pick out the hands and face in raw metal to emphasise the harshness of the features.

space combat mecha

This space mecha can move swiftly to fight in close combat with the enemy.

1 Start by drawing a basic structure for your figure. Based loosely on the human form, this mecha has tremendous brute strength. Choose a posture to reflect this.

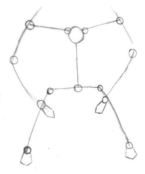

2 Draw in very simple shapes to show where all the joints should be. Add four more for the hands and feet.

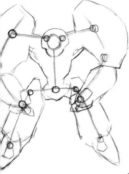

3 Use your basic structure to draw a full outline for your figure. Think about the function of your mecha and give it a solid stable body and strong arms.

4 Develop those areas that will come into their own in close combat – huge defensive shoulders and thick armour plates on the arms and legs.

▶▶

space combat mecha continued

5 Build on your character. This example has no recognisable facial features beneath its mask. Its body is small and compact. The hands are tools for fighting.

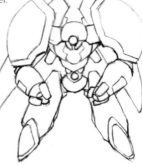

6 With your pencil drawing complete, you can go over your outline using black ink. Draw in lines to show the articulation of the arms and add any final details.

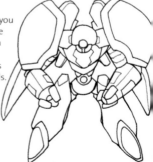

7 Colour up your image. The scheme here is strong and striking. It helps to give the mecha its more imposing appearance. Keep the colours flat.

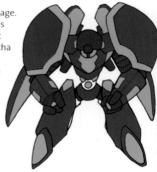

8 Add sharp, bright highlights where the highly polished, painted-metal plates reflect the light. Keep shadows to a minimum to emphasise the effect.

GALLERY

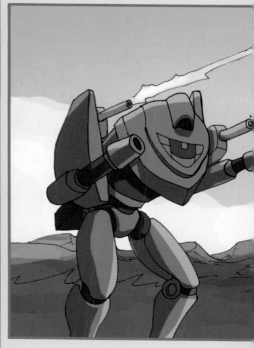

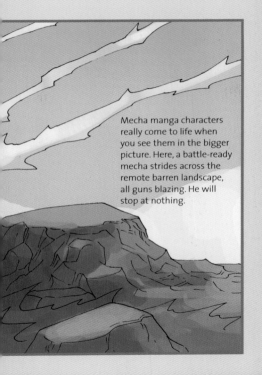

Mecha manga characters really come to life when you see them in the bigger picture. Here, a battle-ready mecha strides across the remote barren landscape, all guns blazing. He will stop at nothing.

GALLERY

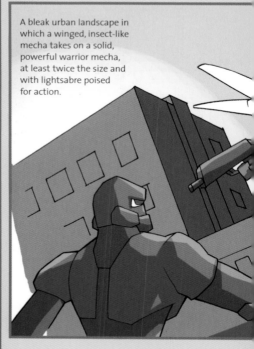

A bleak urban landscape in which a winged, insect-like mecha takes on a solid, powerful warrior mecha, at least twice the size and with lightsabre poised for action.

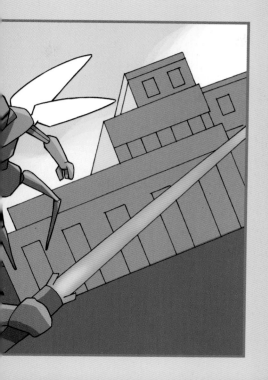

spying dog mecha

A dog spy, complete with a camera in its tail, this creature is lean and muscular.

1 Using pencil, start to draw the basic structure of the dog, considering its proportions carefully.

2 With your initial lines complete, draw in shapes to act as guides for the dog's joints and feet.

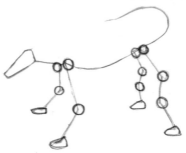

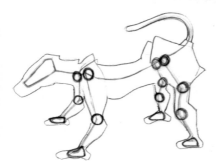

3 Develop the shape of the dog. Think about perspective when you draw outlines for the legs.

4 Start to turn your dog into a mecha. Divide the body into separate angular armoured plates.

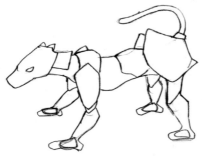

▶▶

spying dog mecha continued

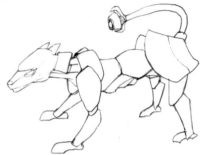

5 Add elements that reflect the mecha's unique function, such as a flexible tail with a camera at the end.

6 Go over your outline using black ink, adding sharp claws.

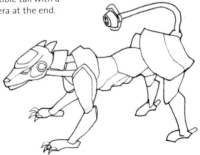

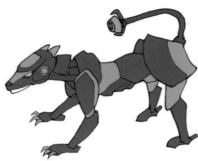

7 Colour up your image, using flat colour. The unrealistic orange and purple scheme suggests that this is not a friendly creature.

8 Drop bright highlights on the curved edges of the armour and add some subtle shadows.

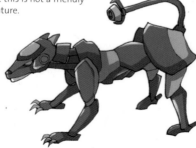

dolphin survey mecha

This dolphin survey mecha performs deep-sea rescue missions aided by its lights.

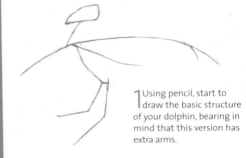

1 Using pencil, start to draw the basic structure of your dolphin, bearing in mind that this version has extra arms.

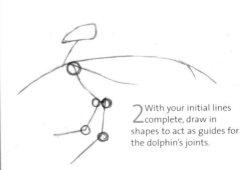

2 With your initial lines complete, draw in shapes to act as guides for the dolphin's joints.

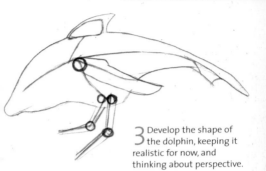

3 Develop the shape of the dolphin, keeping it realistic for now, and thinking about perspective.

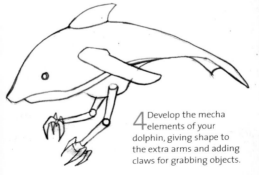

4 Develop the mecha elements of your dolphin, giving shape to the extra arms and adding claws for grabbing objects.

▶▶

dolphin survey mecha continued

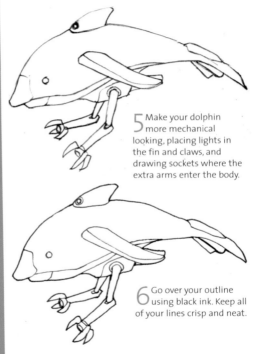

5 Make your dolphin more mechanical looking, placing lights in the fin and claws, and drawing sockets where the extra arms enter the body.

6 Go over your outline using black ink. Keep all of your lines crisp and neat.

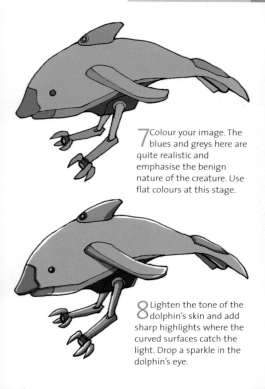

7 Colour your image. The blues and greys here are quite realistic and emphasise the benign nature of the creature. Use flat colours at this stage.

8 Lighten the tone of the dolphin's skin and add sharp highlights where the curved surfaces catch the light. Drop a sparkle in the dolphin's eye.

eagle mecha

This eagle is a fighting machine, typically depicted with outstretched wings and talons descending.

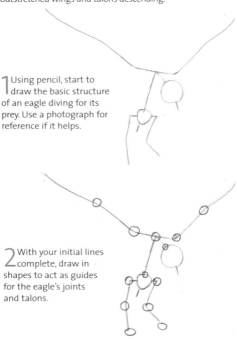

1 Using pencil, start to draw the basic structure of an eagle diving for its prey. Use a photograph for reference if it helps.

2 With your initial lines complete, draw in shapes to act as guides for the eagle's joints and talons.

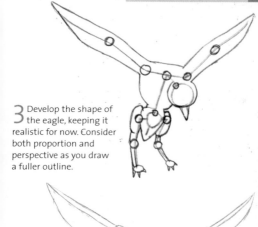

3 Develop the shape of the eagle, keeping it realistic for now. Consider both proportion and perspective as you draw a fuller outline.

4 Build on your outline to give your eagle a more mecha appearance. Emphasise the harsh, angular lines of the bird's wings, beak and talons. Give the joints a more mechanical look.

▶▶

eagle mecha continued

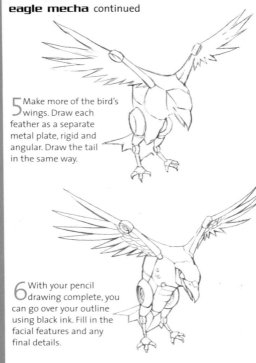

5 Make more of the bird's wings. Draw each feather as a separate metal plate, rigid and angular. Draw the tail in the same way.

6 With your pencil drawing complete, you can go over your outline using black ink. Fill in the facial features and any final details.

7 Colour up your image. Although this version uses realistic colours, the mechanisms that operate the wings and the legs are very prominent, giving the bird an otherworldly appearance. Use flat colour.

8 Finish the eagle, dropping highlights onto the tips of the wings and tail feathers and at the end of the beak, poised for action.

leopard mecha

The leopard is the fastest animal on earth. This mecha version has a streamlined design to make it look lithe.

1 Using pencil, start to draw the basic structure of the leopard.

2 With your initial lines complete, draw in shapes to act as guides for the cat's joints and feet.

3 Develop the shape of the leopard, keeping it realistic for now. Consider the cat's proportions as you draw the head, body and tail. Think carefully about perspective when you draw the legs.

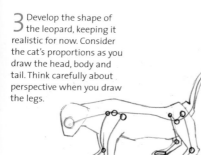

4 Now you can begin to turn your leopard into a mecha. Start to shape the body parts to give them a more angular, machine-made appearance.

▶▶

leopard mecha continued

5 Add elements to give your mecha its own personality, such as an articulated tail and wings for greater speed.

6 With your pencil drawing complete, you can go over your outline using black ink. Fill in any areas that need to be solid black and add any final details – to complete the facial features, for example.

7 Colour up your image. The black and yellow scheme signals danger. Keep your colours flat for now.

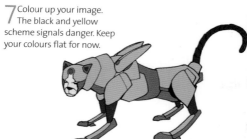

8 This cat has a highly reflective metal surface. Build strong areas of light and shade to emphasise this.

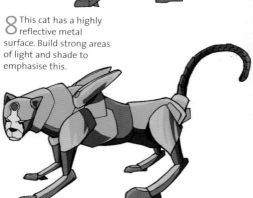

GALLERY

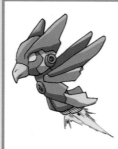

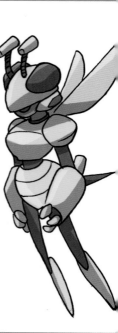

ABOVE A bird mecha. Its natural parrot-like features are exaggerated and it has a rocket projector.

RIGHT This wasp-like mecha has been given human proportions and characteristics.

LEFT A ladybird-like mecha. Its tiny legs have several joints to aid mobility.

RIGHT The power of this bull mecha is emphasised by its solid legs and horns, and its fierce facial features.

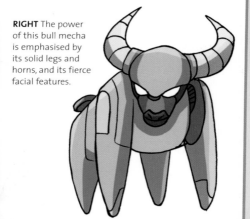

factory mecha

The floating style of this mecha gives it greater mobility, making it ideal for transporting products.

1 Using pencil, start to draw the basic structure of your factory mecha. It does not need to be too complicated, as the function of the mecha is very basic.

2 With your initial lines complete, draw in shapes to act as guides for the mecha's joints and hands.

3 Develop the shape of the mecha, keeping it really very basic. Consider how the arms will operate and how they relate to the body.

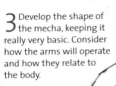

4 Fine tune your lines. Start to shape the main body of the mecha. Give it a more angular, machine-made appearance.

▶▶

factory mecha continued

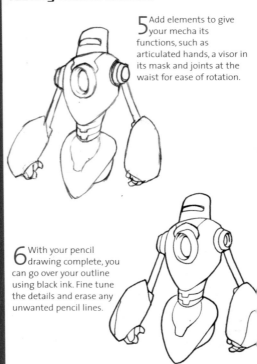

5 Add elements to give your mecha its functions, such as articulated hands, a visor in its mask and joints at the waist for ease of rotation.

6 With your pencil drawing complete, you can go over your outline using black ink. Fine tune the details and erase any unwanted pencil lines.

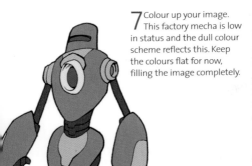

7 Colour up your image. This factory mecha is low in status and the dull colour scheme reflects this. Keep the colours flat for now, filling the image completely.

8 The hard surfaces of the mecha's armour are not shiny. Keep your highlights general and to a minimum – just on those areas that catch the light. Drop in some shadows to keep the image three-dimensional.

transport mecha

The spider-like legs of this transport mecha give it greater maneouverability in tight spaces.

1 Start by drawing your basic structure in pencil. It is important to consider perspective at this stage.

2 With your initial lines complete, draw in shapes to act as guides for the joints on the legs.

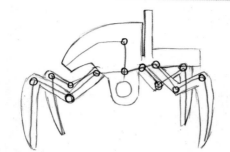

3 Using your initial guidelines to build on the structure. Give shape to the legs and draw in the outline of the body of the machine.

4 Develop your structure further. The weight at the centre counterbalances heavy loads.

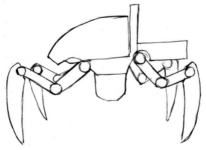

▶▶

transport mecha continued

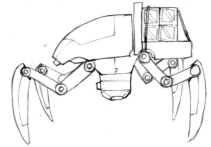

5 Give your pencil drawing more substance. Draw in the viewing window at the front of the cab and add some cargo.

6 With your pencil drawing complete, you can go over your outline in black ink. Add any final details.

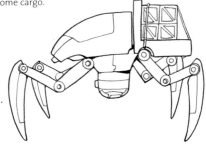

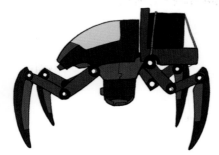

7 Colour up your image. The strong colour scheme helps to emphasise the practical function of this mecha. Keep colours flat for now.

8 Use strong highlights to capture the glossy sheen of the mechanical parts. Drop a bright highlight on the window.

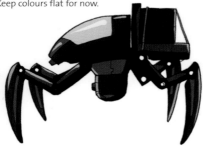

mining mecha

Physical strength is more important than flexibility for this mining mecha, as its time is spent working on the spot.

1 Using pencil, start to draw the basic structure of your mining mecha. Work on the idea that it needs a strong, solid stance.

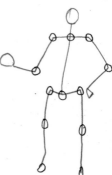

2 With your initial lines complete, draw in shapes to act as guides for the mecha's joints, hands and feet.

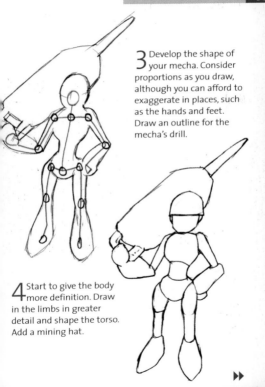

3 Develop the shape of your mecha. Consider proportions as you draw, although you can afford to exaggerate in places, such as the hands and feet. Draw an outline for the mecha's drill.

4 Start to give the body more definition. Draw in the limbs in greater detail and shape the torso. Add a mining hat.

▶▶

mining mecha continued

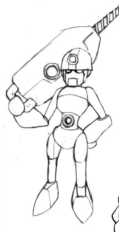

5 Still using pencil, begin to draw in some of the finer details. Give the mecha some facial features and build on the form of the drill.

6 With your pencil drawing complete, you can go over your outline using black ink. Add any final details – to refine the shape of the drill bit, for example.

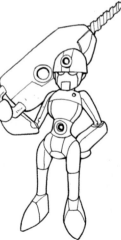

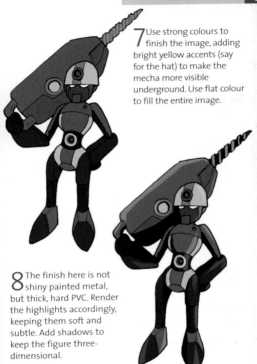

7 Use strong colours to finish the image, adding bright yellow accents (say for the hat) to make the mecha more visible underground. Use flat colour to fill the entire image.

8 The finish here is not shiny painted metal, but thick, hard PVC. Render the highlights accordingly, keeping them soft and subtle. Add shadows to keep the figure three-dimensional.

underwater mecha

The rounded design of this mecha aids its swift movement through the water.

1 Using pencil, start to draw the basic structure of the mecha. This example has a very simple body structure with two huge arms.

2 With your initial lines complete, draw in shapes to act as guides for the mecha's joints – there are not many of them.

3 Develop the shape of your mecha, keeping it really very basic. Consider how the arms will operate and how they relate to the body. Here, the engine is placed behind the body so that it can drive the mecha forward.

4 Give more shape to the huge arms, their size being suited to moving large objects under water. Keep the armour plates big to prevent water getting in.

▶▶

underwater mecha continued

5 Add elements to give your mecha its functions, such as articulated, rotating hands and a central light source. Give more shape to the large splash of water that gives the mecha a feeling of motion.

6 With your pencil drawing complete, you can go over your outline using black ink. Add any final details – to refine the joints of the hands, for example.

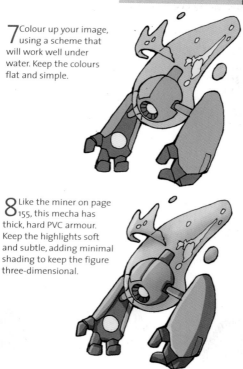

7 Colour up your image, using a scheme that will work well under water. Keep the colours flat and simple.

8 Like the miner on page 155, this mecha has thick, hard PVC armour. Keep the highlights soft and subtle, adding minimal shading to keep the figure three-dimensional.

repair mecha

This mechanical repair mecha has a body and arms that are linked by tubes, making it extra flexible.

1 Using pencil, start to draw the basic structure of your repair mecha. Consider how its shape should complement its function.

2 With your initial lines complete, draw in shapes to act as guides for the mecha's joints, hands and feet.

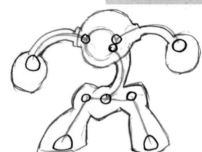

3 Develop the shape of your mecha. Consider proportions as you draw, although you can afford to exaggerate in places, such as the hands and feet.

4 Start to give the body more definition. Show how the limbs join the body and draw in a protective hat.

▶▶

repair mecha continued

5 Still using pencil, begin to draw in some of the finer details, such as the flexible tubing that makes up much of the arms and body. Give your mecha a tool to hold.

6 With your pencil drawing complete, you can go over your outline using black ink. Add any final details.

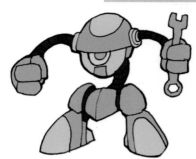

7 This mecha is purely functional and does not need a striking colour scheme. Apply flat colour to all areas of the image.

8 Made from hard PVC, the armour of this mecha has soft shadows and subtle highlights.

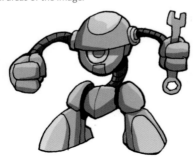

GALLERY

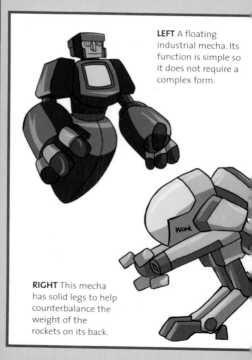

LEFT A floating industrial mecha. Its function is simple so it does not require a complex form.

Work

RIGHT This mecha has solid legs to help counterbalance the weight of the rockets on its back.

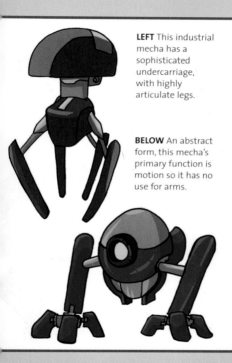

LEFT This industrial mecha has a sophisticated undercarriage, with highly articulate legs.

BELOW An abstract form, this mecha's primary function is motion so it has no use for arms.

butler mecha

Designed for home use, this mecha has a very human quality to it – right down to its suit and moustache.

2 With your initial lines complete, draw in shapes to act as guides for the butler's joints, hands and feet.

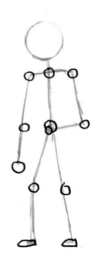

1 Using pencil, start to draw the basic structure of your mecha. In this case, it has quite human proportions.

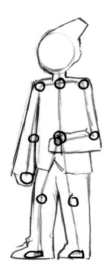

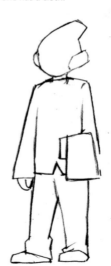

4 Develop the shape of your mecha, adding hands and any props – this one has a cloth.

3 Develop the shape of the mecha, keeping it realistic for now. Draw an outline for hair, suit and shoes.

▶▶

butler mecha continued

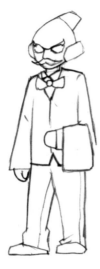

6 With your pencil drawing complete, you can go over your outline using black ink. Add any final details.

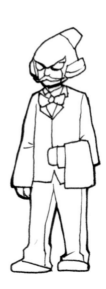

5 Add elements to give your mecha its own personality. Draw in any facial features and add more detail, such as a bow tie, to the suit.

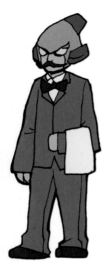

8 Add highlights to show where the butler's helmet catches the light. Drop in some shadows to emphasise folds in the fabric of the suit.

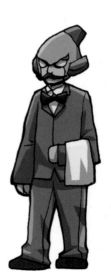

7 Colour up your drawing, using a realistic colour for skin tones and a sombre colour for the suit.

medical mecha

The floating style of this medical mecha gives it greater mobility in the hospital environment.

1 Using pencil, start to draw the basic structure of your medical mecha. It does not need to be too complicated, as the function of this mecha is very basic.

2 With your initial lines complete, draw in shapes to act as guides for the mecha's joints and hands.

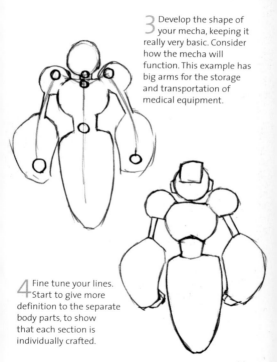

3 Develop the shape of your mecha, keeping it really very basic. Consider how the mecha will function. This example has big arms for the storage and transportation of medical equipment.

4 Fine tune your lines. Start to give more definition to the separate body parts, to show that each section is individually crafted.

▶▶

medical mecha continued

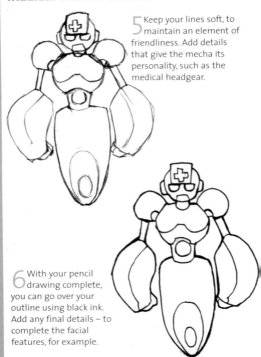

5 Keep your lines soft, to maintain an element of friendliness. Add details that give the mecha its personality, such as the medical headgear.

6 With your pencil drawing complete, you can go over your outline using black ink. Add any final details – to complete the facial features, for example.

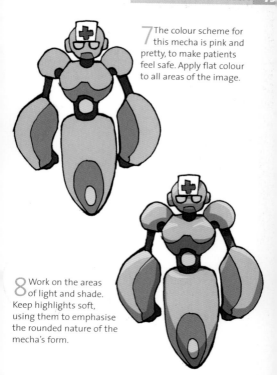

7 The colour scheme for this mecha is pink and pretty, to make patients feel safe. Apply flat colour to all areas of the image.

8 Work on the areas of light and shade. Keep highlights soft, using them to emphasise the rounded nature of the mecha's form.

bodyguard mecha

The physical appearance of this mecha is one of power and brute strength, in keeping with its role as a protector.

1 Draw the basic structure of your bodyguard mecha, using pencil. Try to capture the menacing stance in just a few lines.

2 With your initial lines complete, draw in shapes to act as guides for the mecha's joints, hands and feet.

3 Develop the shape of your mecha, using your basic structure as a guide. Draw a muscular outline, paying particular attention to the shoulders and hips. Give the mecha big hands and feet.

4 With your outline complete, start to focus on the body parts. Divide your mecha into sections that demonstrate his basic construction.

bodyguard mecha continued

5 Give the mecha some personality. In this case, a small tuft of hair and worker-style outfit counter the powerful physique to give the mecha a more honest, loyal character.

6 With your pencil drawing complete, you can go over your outline using black ink. Keep your lines sharp and erase any unwanted pencil.

7 Colour up your image. This bodyguard is not an attractive figure, so colours are dull and oppressive. Apply flat colour throughout.

8 Use lighter tones of your colours to build up a three-dimensional appearance. Save the brightest highlights for the curved surfaces of the bodyguard's armour as they catch the light.

GALLERY

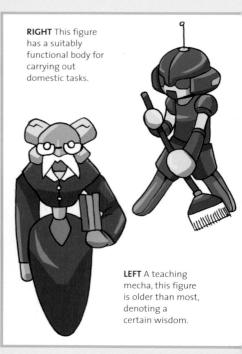

RIGHT This figure has a suitably functional body for carrying out domestic tasks.

LEFT A teaching mecha, this figure is older than most, denoting a certain wisdom.

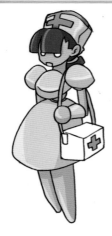

LEFT The colour pink and feminine characteristics make this mecha look kind and caring.

RIGHT Human clothing gives this service mecha a friendly appearance.

chibi mecha

With huge heads, chibi's are typically cute. Their big eyes make them particularly appealing to children.

1 Use pencil to draw a basic structure for your chibi mecha. Keep the head large and round.

2 With the basic structure drawn, add small shapes to show where the joints, hands and feet are.

3 Develop your outline. Consider perspective carefully as you draw the limbs in greater detail. Give more shape to the head – this version has an aerial.

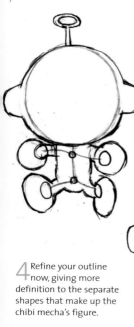

4 Refine your outline now, giving more definition to the separate shapes that make up the chibi mecha's figure.

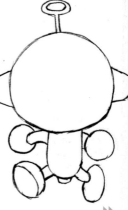

▶▶

chibi mecha continued

5 Give your chibi mecha some personality. Draw in the facial features and any additional details you'd like to include – in this case there is a flame projector to assist mobility.

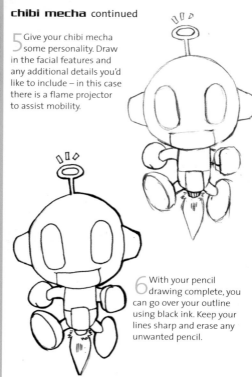

6 With your pencil drawing complete, you can go over your outline using black ink. Keep your lines sharp and erase any unwanted pencil.

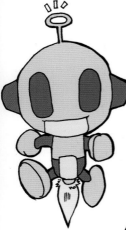

7 This chibi has a friendly appeal, so finish him in neutral colours that emphasise the fact that he is benign. Use flat colour throughout at this stage.

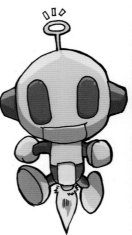

8 The chibi is made from hard PVC, so the surface is soft and rather matte. Add highlights and shadows, but keep them soft and subtle.

chibi police mecha

This figure is based on the police mecha on page 89. The cute features of the chibi give it a less serious appearance.

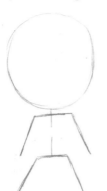

1 Using pencil, start to draw a basic structure, keeping the head large and round. Think about the chibi mecha's stance. Here, the legs are wide apart to express authority.

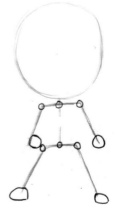

2 With the basic structure drawn, add small shapes to show where the joints, hands and feet are.

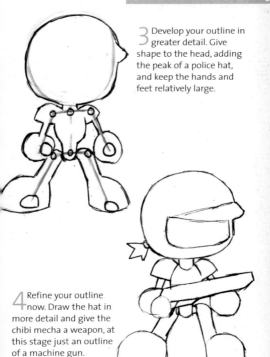

3 Develop your outline in greater detail. Give shape to the head, adding the peak of a police hat, and keep the hands and feet relatively large.

4 Refine your outline now. Draw the hat in more detail and give the chibi mecha a weapon, at this stage just an outline of a machine gun.

▸▸

chibi police mecha continued

5 Draw in the chibi mecha's facial features, give more shape to the machine gun and add any remaining details, such as the word 'police' on the hat.

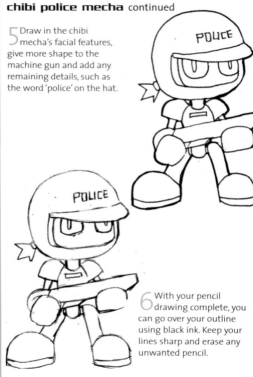

6 With your pencil drawing complete, you can go over your outline using black ink. Keep your lines sharp and erase any unwanted pencil.

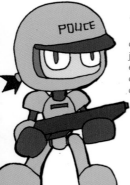

7 Colour up your image. Blue is an obvious colour, and also symbolises justice. Use a pale blue to emphasise the chibi's cuteness and keep the colours flat for now.

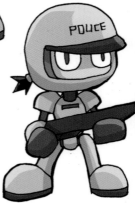

8 Finish the chibi with soft highlights to render the smoothness of the PVC armour. Drop in a few shadows to keep the image looking three-dimensional.

GALLERY

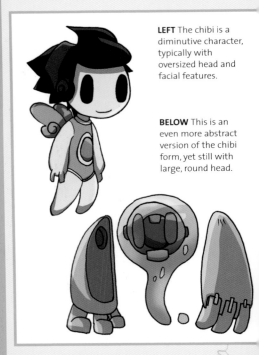

LEFT The chibi is a diminutive character, typically with oversized head and facial features.

BELOW This is an even more abstract version of the chibi form, yet still with large, round head.

RIGHT This chibi has a square head, which does much to reduce its cute appearance.

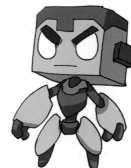

BELOW Chibis can take on a wide range of functions, just as full-size mechas can.

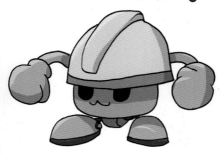

index

accessories 46–47
Adobe Photoshop 18
animal inspiration 22–23
animal mechas 28, 124, 126–143
animal symbolism 40
armorial symbolism 43
arms 34
assassin mecha 106–109
axes 52

balance 26–29
 in human forms 26–27
 in non-human forms 28–29
basic fighting mecha 82–85
bird mechas 134–137, 142
bodyguard mecha 174–177
brush pens 15
bull mecha 143
butler mecha 166–169

chainsaws 52
characteristics, mecha 7–9
chibi mechas 180–189
chibi police mecha 184–187
child body mecha 76–79
cold weapons 48–49
colouring 14–15, 16

colour markers 15
comic strips 6, 19
computers, using 18–19

dolphin survey mecha 130–133
drawing 12–13
drawing aids 13
drills 53

eagle mecha 134–137
electromagnetic pulse 57
erasers 12
equipment 10–19
 brush pens 15
 computers 18
 drawing aids 13
 graphics tablet 19
 ink pens 14
 paints 15
 papers 16–17
 pencils 12, 15
 rubbers 12
 rulers 13
 sketchbooks 16
 stencils 13

faces 32
factory mecha 144–147
female body mecha 72–75,
 80
fighting mechas 31, 42–43,
 82–85, 102–105, 110–121
firearms 50–51
flames, how to draw 62–63

gauss gun 55
geometric symbolism 45
glass, colouring 58–59
graphics tablet 19

hands 33
hammers 53
heavy weaponry mecha
 90–93
human forms 20–21, 26,
 68–81

industrial inspiration 24–25
industrial mechas 30, 39,
 81, 144–165
industrial symbolism 39, 40
inking 14, 16
ink pens 14
inspiration 9, 20–25
ion cannon 54

Japanese symbolism 44
joints 36–37

knives 48

ladybird mecha 143
lasers 54, 64–65
 how to draw 64–65
legs 35
leopard mecha 138–141
lightsabre 57, 125

maces 48
male body mecha 68–71, 81
mecha characteristics 7–9
medical mechas 170–173,
 179
metal, colouring 58–61
military mechas 31, 38, 42,
 80, 82–125
military symbolism 38, 42
mining mecha 152–155

ninja mecha 102–105
non-human forms 28–29

index

paints 15
papers 16–17
particle cannon 55
pencils 13
 colour 15
perspective 8
plasma weapons 56
plastics, colouring 58–59
police mechas 86–89,
 184–187
proportion 8
PVC, colouring 58–59

repair mecha 160–161
rulers 13

sci-fi weapons 54–57
scythes 49
service mechas 41, 166–179
service symbolism 41
sketchbooks 16
space combat mecha
 118–121
space fighting mecha
 110–113

space warrior mecha
 114–117
spying dog mecha 126–129
spy mecha 98–101
stencils 13
swords 49
symbols 38–45, 173

tank mecha 94–97
teaching mecha 178
Tesla gun 56
textures 58–59
tools 52–53, 155, 163
 as weapons 52–53
transport mecha 148–151

underwater mecha 156–159

wasp mecha 143
weapons 48–57, 85, 89, 93,
 97, 105, 109, 117, 187
wood, colouring 58–59